Peter Caldwell

Draw Boats & Harbours

Series editors: David and Brenda Herbert

A & C Black · London

First published 1980
New style of paperback binding 1995
by A & C Black (Publishers) Limited
35 Bedford Row, London WC1R 4JH

Reprinted 1999

ISBN 0-7136-4271-8

© 1980 A & C Black (Publishers) Limited

Printed in Hong Kong by Wing King Tong

Contents

Making a start

The instinct to draw is strong in all of us, beginning in childhood. Too often it is suppressed later, and many people who haven't put pencil to paper since their schooldays would surprise themselves if they made serious efforts to sketch now.

Before mankind learned to write, drawing was the only medium, apart from speech, through which he could communicate and, with a little perseverence, anyone today can draw, even if his results aren't as good as an expert's.

Drawing is a pleasant, relaxing experience, which encourages you to look at everything more closely and so get to know it better than you would normally do. Much of it too can be done out of doors, so you get the benefit of fresh air.

Just as people's handwriting has individual characteristics, no artist draws or paints exactly like another. Even if you start by copying a particular artist's style or technique, your own characteristics will gradually creep in the more you draw, and you will develop a style and technique of your own.

Most people find harbours and boatyards fascinating places to visit. A sense of adventure and romance surrounds every boat and piece of tackle, and the air is full of smells (salt, seaweed, fish and tar), as well as such noises as the wild screeching of gulls.

Always keep a sketchbook by you—both because sketching is fun in itself, and in order to record what you see for future use in a picture. Some of my smaller sketches are like pictorial shorthand notes, recording an unusual pattern that caught my eye, or a fleeting trick of light.

Before finally committing a drawing on to a good quality paper or board, I make numerous sketches—of such things as interesting shadows, types of building materials, and textures. Enlarged details of important or elaborate boat construction are carefully noted, and anything else which might help the lay-out and composition of the final drawing. For more finished sketches I use a smooth-surfaced white paper.

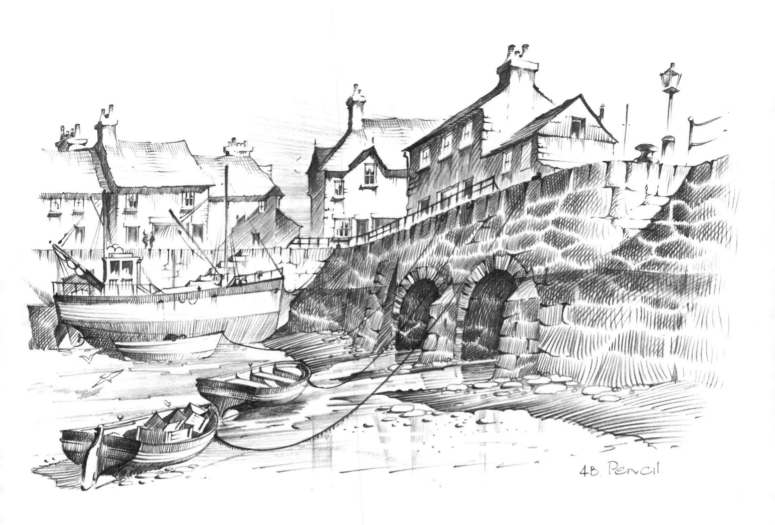

4B. Pencil.

Learning to draw (or developing any other talent) is like learning to drive a car. There are three phases to go through. You first need to be shown how to use the basic equipment. Then you have to go through the sometimes agonising business of constant practice, trying to get accustomed to which piece of equipment does what. As with driving a car, you realize that gradually you are doing things without thinking so much about them, and consequently you are more relaxed and enjoy the experience more. As with handwriting too — you stop thinking about style once you are practised, and just concentrate on the message.

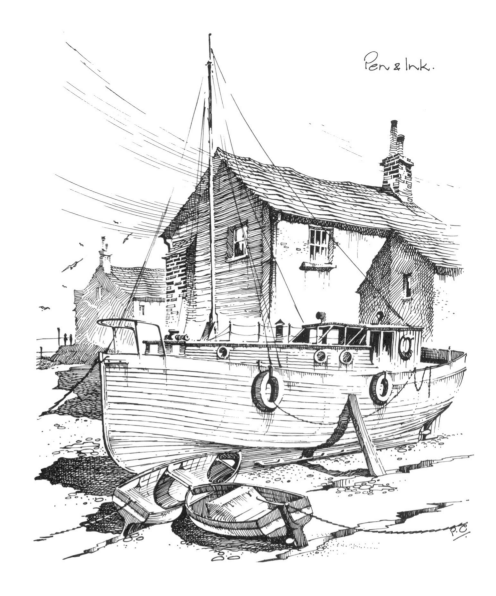

Pen & Ink.

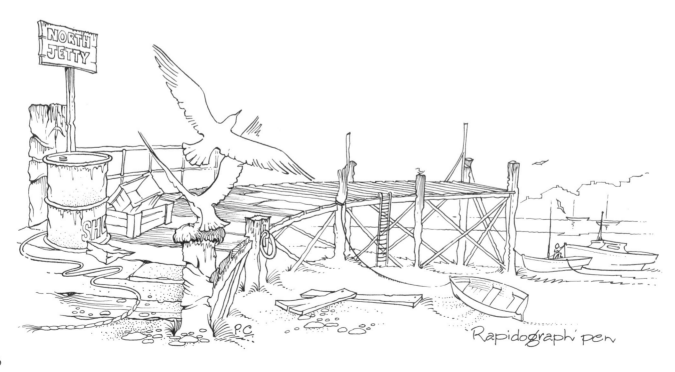

Rapidograph pen

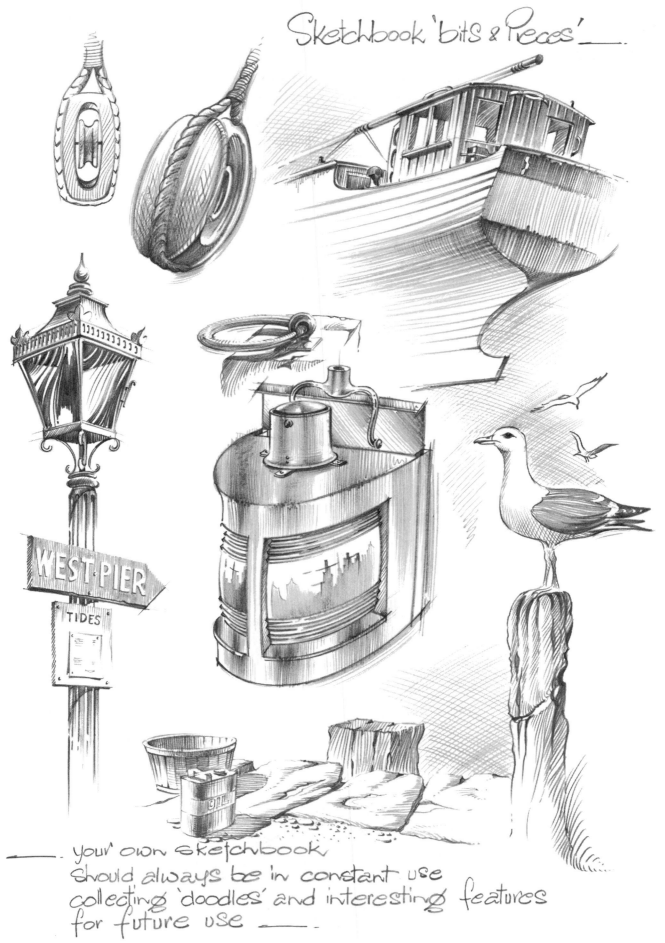

WEST·PIER

TIDES

9½L

__. your own sketchbook
should always be in constant use
collecting 'doodles' and interesting features
for future use ___.

What to draw on

Compared with other art mediums—and most other hobbies or pursuits—drawing requires very little, and only very inexpensive equipment. Everything can be carried around in a pocket (or a small hold-all) except, of course, paper. Paper comes in all shapes and sizes and surfaces—even brown wrapping paper and lining paper for wall covering have suitable surfaces for charcoal and soft crayons. But there are many brands made specially for the artist. These include the following:

Ledger Bond paper ('cartridge' in the UK), the most usual drawing paper, which is available in a variety of surfaces—smooth, 'not surface' (semi-rough), and rough.

Ingres paper, which is mainly for pastel drawings. It has a soft, furry surface and is made in many light colours—grey, pink, blue, buff etc.

Bristol board, which is a smooth, hard white board available in various thicknesses, and designed for fine pen work.

Sketchbooks made up from nearly all these papers are available. Choose one with thin, smooth paper to begin with. Thin paper means more pages, and a smooth surface is best to record detail.

Lay-out pads make useful sketchbooks. Although their covers are not stiff, you can easily insert a stiff piece of card to act as firm backing to your drawing. The paper is semi-transparent, but this can be useful, in almost the same way as tracing paper if you want to make a new, improved version of your last drawing.

An improvised sketchbook can be just as good as a bought one—or better. Find two pieces of thick card or ply, sandwich a stack of paper, preferably of different kinds, between them and clip together at either end. Or better still make a wooden sketching folder like the one shown in the diagram.

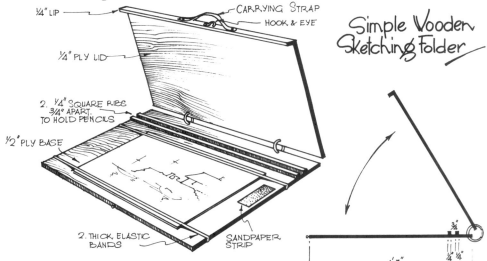

¼" LIP
CARRYING STRAP
HOOK & EYE
Simple Wooden Sketching Folder
¼" PLY LID
2. ¼" SQUARE RIBS ¾" APART. TO HOLD PENCILS
½" PLY BASE
2. THICK ELASTIC BANDS
SANDPAPER STRIP
1'3"
¾"
¼" ¼"

What to draw with

Pencils are graded according to hardness, from 6H (the hardest) through 5H, 4H, 3H, 2H to H; then HB, then B, through 2B, 3B, 4B, 5B, up to 6B (the softest). For most purposes a soft pencil (HB or softer) is best. If you keep it sharp, it will draw as fine a line as a hard pencil but with less pressure, which makes it easier to control. The pencil is your basic drawing implement and will do everything required of it, from a small rough sketch to a more elaborately finished drawing. Having said that, most people only half use a pencil, missing out on the shading it is capable of. The side of the lead is as pleasant to draw with as the point. I recommend keeping two pencils by your side when drawing, one for outlines and detail—the other for shading. If you only use one pencil, you will find yourself forever sharpening the point.

Charcoal stick (which is very soft) is excellent for large, bold sketches, but no good for detail. If you want detail, you can use a charcoal pencil to put it in. Beware of accidental smudging.
A charcoal drawing can even be dusted or rubbed off the paper altogether. Drawings done with this medium must be 'fixed' on completion, gently spraying it with an 'aerosol' fixative.

Wax crayons are quite soft but not easily smudged or erased. Again these are exellent for large, bold sketches and are available in a range of colours, as well as black and white.

Oil pastels, marker pencils, chinagraph and lithographic chalk have a similar quality and feel as wax crayons. They can be used with great effect on almost any type of surface.

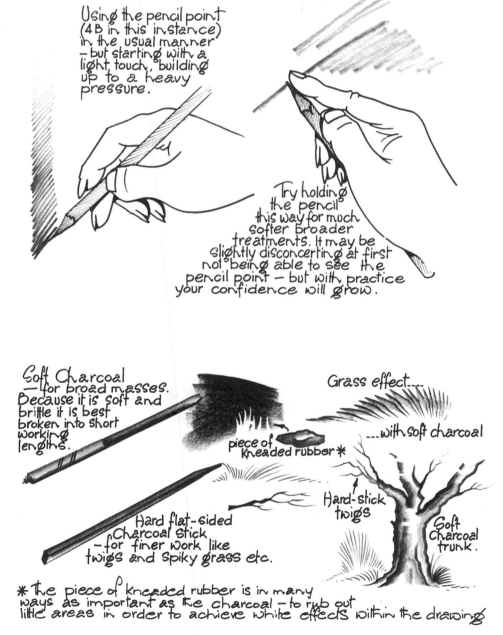

Using the pencil point (4B in this instance) in the usual manner – but starting with a light touch, building up to a heavy pressure.

Try holding the pencil this way for much softer broader treatments. It may be slightly disconcerting at first not being able to see the pencil point – but with practice your confidence will grow.

Soft Charcoal – for broad masses. Because it is soft and brittle it is best broken into short working lengths.

piece of kneaded rubber *

Grass effect....

....with soft charcoal

Hard-stick twigs

Soft Charcoal trunk.

Hard flat-sided Charcoal stick – for finer work like twigs and spiky grass etc.

* The piece of kneaded rubber is in many ways as important as the charcoal – to rub out little areas in order to achieve white effects within the drawing

9

Conté crayons in solid sticks or in pencil form, are available in various degrees of hardness. There are three main colours—black brown and white—but nowadays there is also a full range of Conté pencils. The solid sticks are fun to use, and very satisfying effects can be obtained using the side of the stick—almost in the same way as the side of a long sharp pencil. Conté is harder than charcoal and used correctly gives soft, rich texturing. Drawings should be fixed with 'aerosol' fixative.

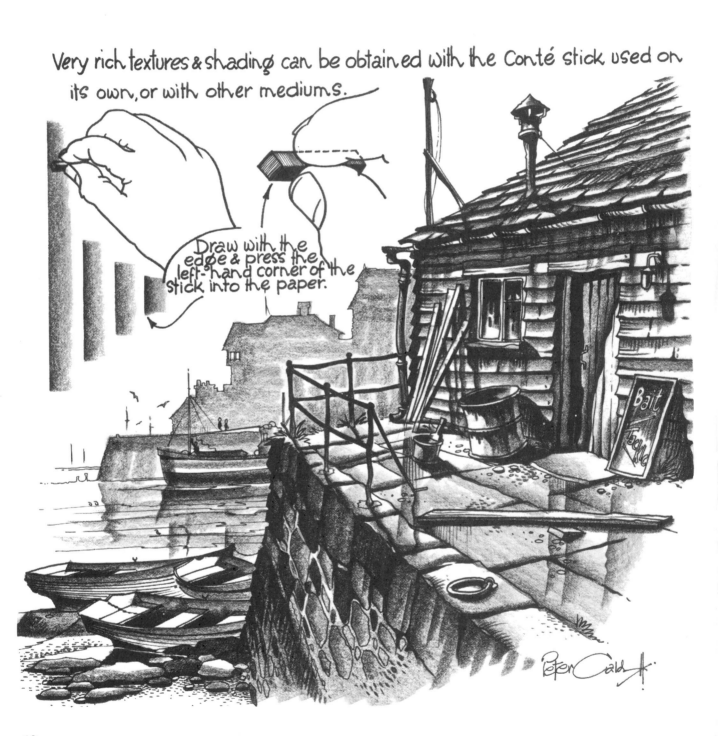

Very rich textures & shading can be obtained with the Conté stick used on its own, or with other mediums.

Draw with the edge & press the left-hand corner of the stick into the paper.

Pastels are softer still and available in a wide range of colours. Even though one can draw with pastels, their great potential widens the purely 'drawing' technique, and finished works in this medium are called 'paintings'. Pastel painting needs a book to itself.

Pens vary as much as pencils and crayons. Ink has a quality of its own and of course it cannot easily be erased. If you would still like to try ink, make up your mind exactly what you want to do and do it positively. There's no turning back once the strokes have been made. Given that, ink is very satisfying to work with.

Special artists' pens such as Gillot 303 and 404 allow you a more varied and flexible line, according to the angle at which you hold them and the pressure you use.

Reed, bamboo and quill pens are fun to use and good for large, bold line drawings. You can make the nib end narrower or wider with the help of a sharp knife or razor blade.

Fountain pens have a softer touch than dip-in pens, and many artists prefer them. Special fountain pens, such as 'Rapidograph' and 'Rotring' control the flow of ink by means of a needle valve in a fine tube nib. Nibs are available in several grades of fineness and are interchangeable. The line they produce is of even thickness, but on coarse paper you can draw an interesting broken line. These pens must be held at a right angle to the paper to operate efficiently.

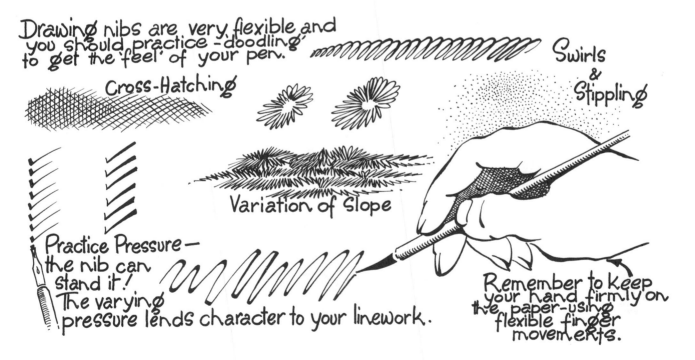

Drawing nibs are very flexible and you should practice 'doodling' to get the 'feel' of your pen.

Swirls & Stippling

Cross-Hatching

Variation of Slope

Practice Pressure — the nib can stand it! The varying pressure lends character to your linework.

Remember to keep your hand firmly on the paper—using flexible finger movements.

Fibre and felt tip pens are extremely easy drawing tools to use. There is no need to worry about 'dipping in' or sharpening. Choose among the many varieties now on the market by what feels right for you to hold. Finished pen sketches can be enhanced by Conté crayon shading or by brushing a watercolour wash into some areas. A word of warning: most felt pens are acid-based and make a strong line or mark which can spread slightly on certain porous papers (you might like this spreading effect—it can soften otherwise hard lines). A watercolour wash will go over felt lines, but fibre tip pens are water-based and therefore soluble. In this tugboat drawing, I applied clean water with a sable brush to give a rough-water effect to the completed drawing. The technique is simply to brush on the water and let the lines 'melt away' of their own accord.

Brushes are most versatile drawing instruments. The Chinese and Japanese know this, and until recently never used anything else for writing. The biggest sable brush has a fine point, and the smallest brush laid on its side provides a line broader than the broadest nib. You can add depth and variety to a drawing by washing over it with a brush dipped in clean water.

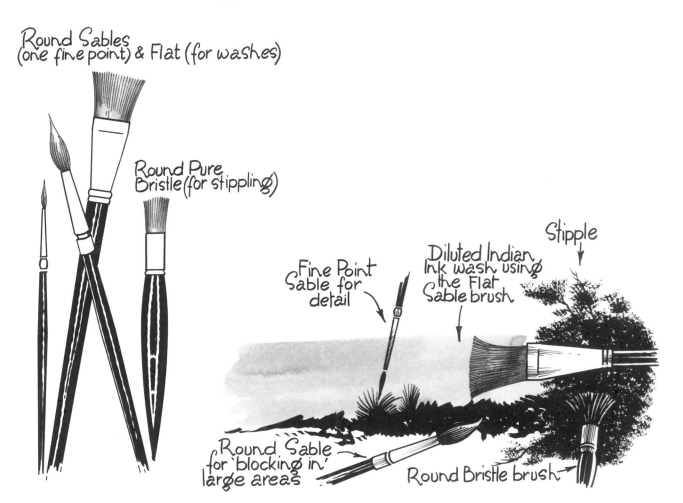

Round Sables (one fine point) & Flat (for washes)

Round Pure Bristle (for stippling)

Fine Point Sable for detail

Diluted Indian Ink wash using the Flat Sable brush

Stipple

Round Sable for 'blocking in' large areas

Round Bristle brush

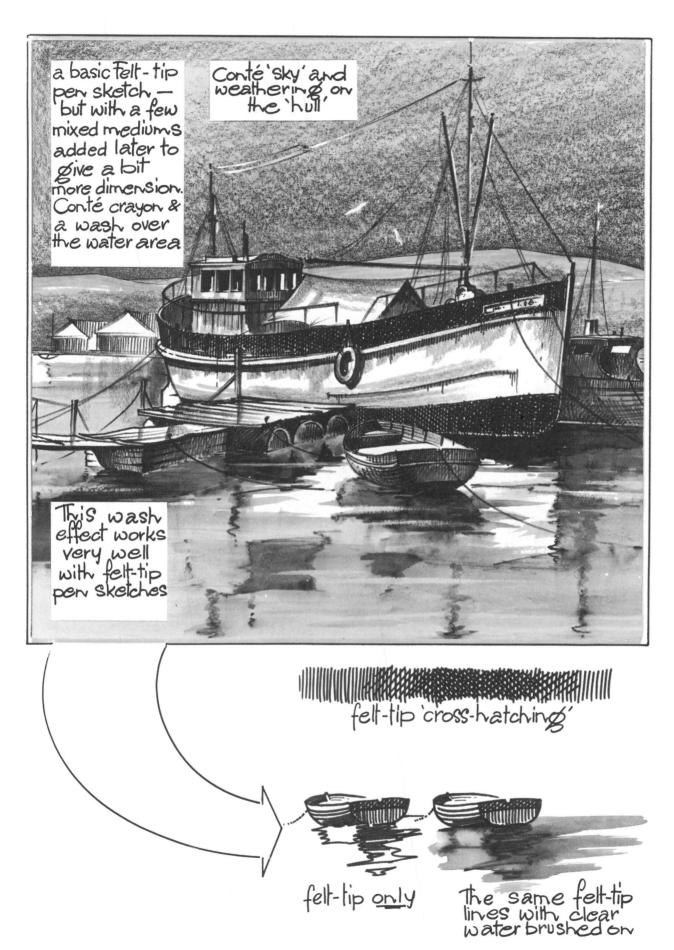

a basic felt-tip pen sketch — but with a few mixed mediums added later to give a bit more dimension. Conté crayon & a wash over the water area

Conté 'sky' and weathering on the 'hull'

This wash effect works very well with felt-tip pen sketches

felt-tip 'cross-hatching'

felt-tip only

The same felt-tip lines with clear water brushed on

13

Inks vary considerably. Waterproof Indian ink quickly clogs the pen. Pelikan 'Fount India' which is nearly as black, flows more smoothly and does not leave a deposit on the pen. Ordinary fountain pen or writing inks (black, blue, green or brown) are not so opaque and give a drawing more variety of tone. You can mix water with any ink in order to make it even thinner. But if you are using Indian ink, add distilled or rain water, because ordinary water will cause the ink to curdle.

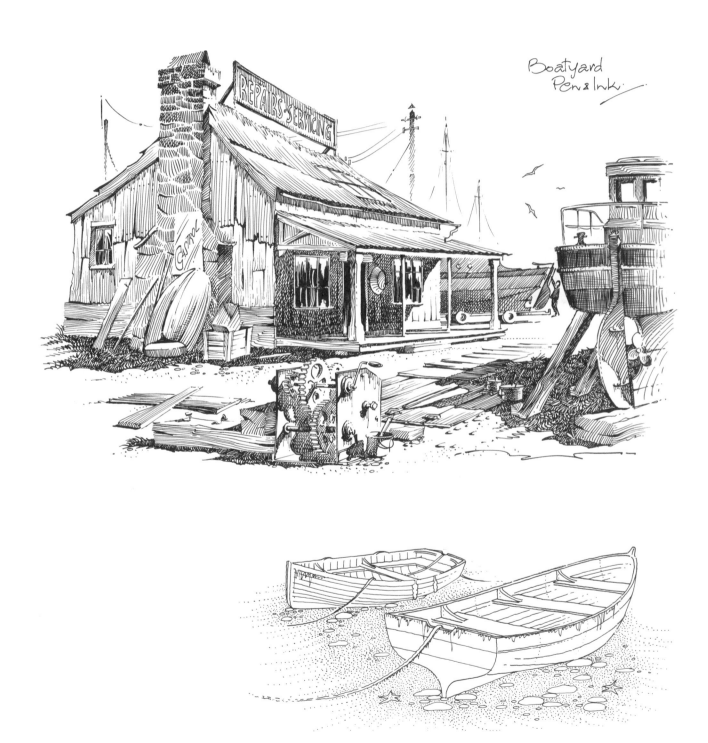

Boatyard
Pen & Ink.

14

PENCIL. 4B

PEN and INK

FINE BRUSH & INK

PEN, INK and WASH

CONTÉ PENCIL & STICK

CHINAGRAPH PENCIL

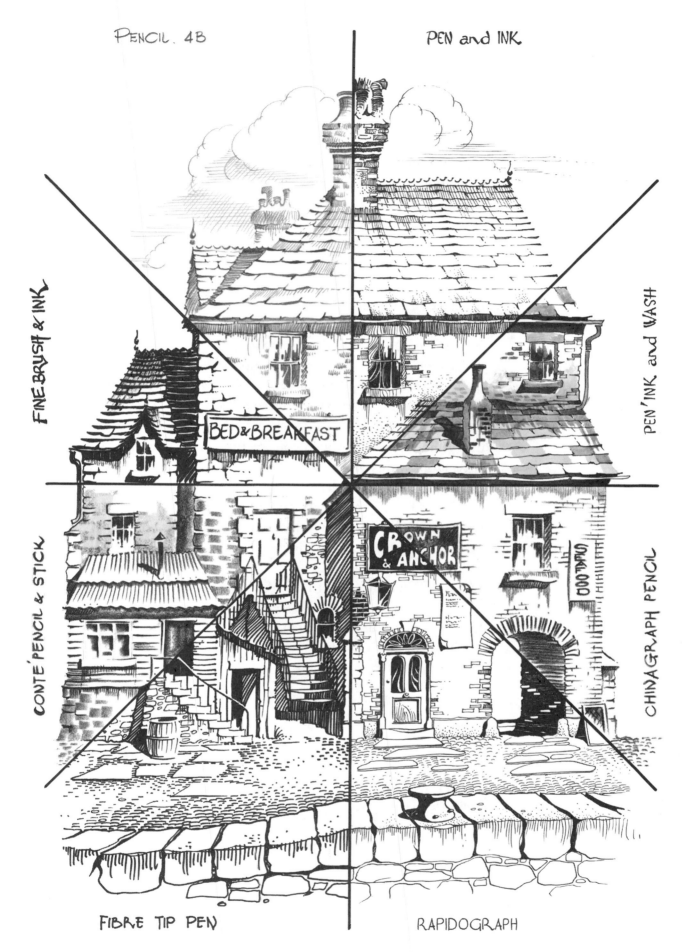

BED & BREAKFAST

CROWN & ANCHOR

SEAFOOD

FIBRE TIP PEN

RAPIDOGRAPH

Perspective

You can be an artist without knowing anything about perspective. Five hundred years ago, when some of the great masterpieces of all time were painted, the word did not even exist. But most beginners want to know something about it in order to make their drawings appear three-dimensional.

Having said this as a sweetener, bad perspective can ruin your picture no matter how well you pay attention to other details. You can't cover it up with any amount of additional drawing.

Perspective is a 'bugbear' of many (though others find it comes naturally) and the more they get involved with complicated rules the more nightmarish the whole business becomes. Stick to simple perspective rules, and remember that what looks right is right.

It is best to put in one or two main guide lines to keep yourself in order. Don't try to work out the perspective of the whole drawing at once. Draw one simple building in the scene until it looks and feels right on its own. Then extend the roof lines and the base of the building until they meet in the distance. These are your vanishing points, and everything else you draw in your picture will extend from these points. If you follow this procedure everything will tie in and look right. It is a simple procedure, and may not work with very complicated subjects. But face those when the time comes. Don't over-complicate to begin with, and DON'T try to work out your vanishing points first, until you are more practised and confident.

DRAW ONE OBJECT IN THE SCENE FIRST—EXTEND YOUR LINES FAINTLY AND MAKE VANISHING POINTS—NOW DRAW IN THE REST—and remember that everything diminishes in size the further away it is. In addition rely on your own judgement to make necessary adjustments.

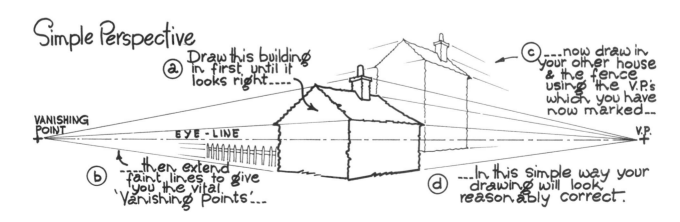

Perspective of Objects and Reflections

Eye of Observer

These two Angles are exactly the same

Angle of Incidence

Angle of Reflection

Surface of Water

* The top of the reflected post below the surface of the water is exactly the same as the top of the post is above the surface.

Vanishing point

EYE·LINE

Vanishing point

'Tide in' and the Jetty is reflected to the <u>same</u> vanishing points.

* Reflection and wall height are the same.

Remember:
The same vanishing points are used for both the object and the reflection.

Vanishing point

Vanishing point

EYE·LINE

Stretch of water

* These vertical heights in reality and in the reflection are the same.

Composition and general layout

Careful attention to this is important if a picture is to have balance or any sort of design about it. Choose an original viewpoint if possible— or at least an angle on the subject which shows it to its best advantage. For example, if the appeal of an old harbour lies in its being hemmed in by tall cliffs, then don't be so close-up that you have to exclude most of the cliffs; and you might find that looking through some foreground rocks or boats adds to the secluded atmosphere.

Make up your mind what it is about the subject that appeals to you, and enhance that appeal, even to the exclusion of other attractions. Don't be sidetracked—the other attractions can await their turn as subjects.

Every good artist is as good as his approach and originality, and sometimes tries to do what no one else has done before. Every human being is unique. However poor an artist you might think you are, you are different from everyone else and your drawing is an expression of your individuality—even if doing it that way means breaking the rules.

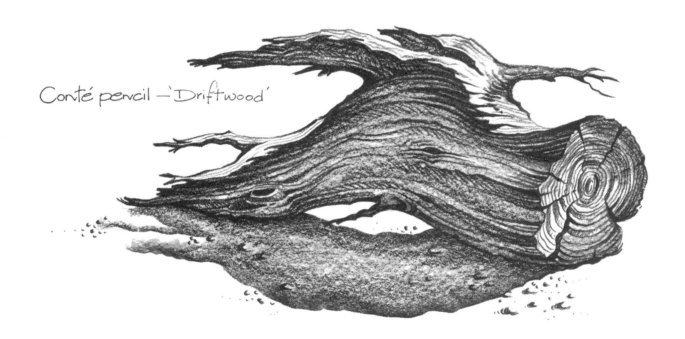

Conté pencil –'Driftwood'

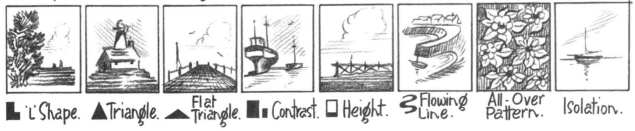

Most pictures conforming to one of these basic shapes will be pleasing to the eye.

'L' Shape. ▲Triangle. Flat Triangle. Contrast. Height. Flowing Line. All-Over Pattern. Isolation.

theres no excuse if you can't find just the harbour view you're looking for — a few pieces of quayside equipment put to-gether makes an interesting 'Still-life'

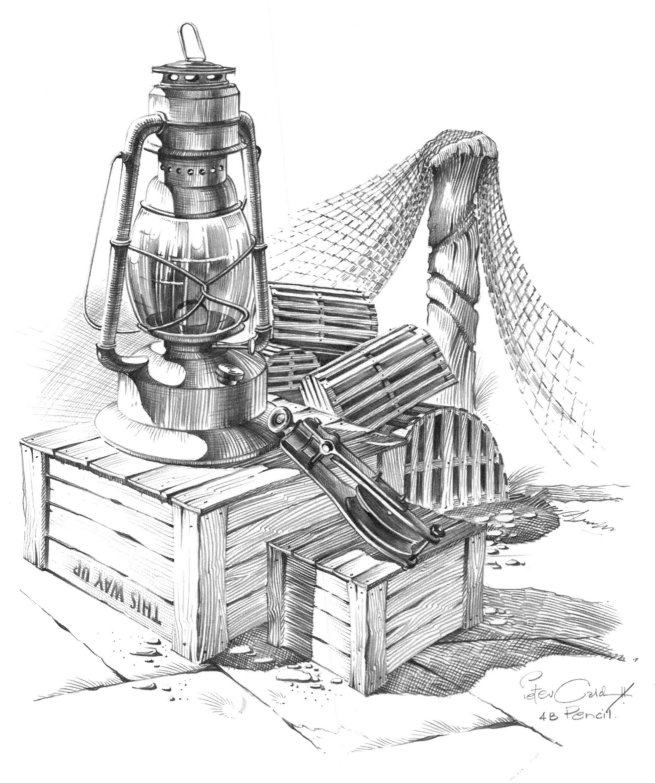

THIS WAY UP

Peter Caldwell
4B Pencil.

Like people, the character or individuality of a drawing is more interesting than the smoothness of its technique or accuracy of detail.

An important lesson to be learnt (simple in theory, though difficult in practice) is that of knowing where to finish, how much to leave out. It is something that only practice and experience can teach.

When making a precise and detailed drawing it is more important still to decide how much you can safely leave out and how much you can 'suggest'.

Start by outlining the objects of the drawing, then indicate the materials these are made of—the wooden planking of the boats, the slates and bricks or stone of buildings, etc. But don't try to draw every plank, stone or slate. This would be unnecessary and boring. Be selective and suggest.

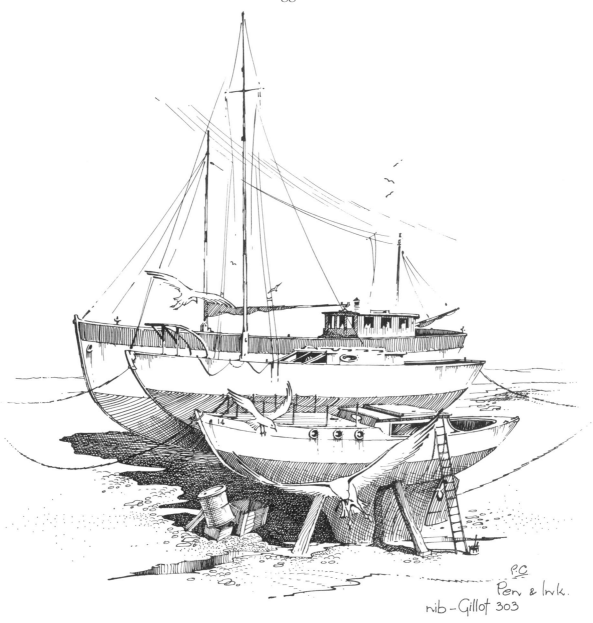

P.C
Pen & Ink.
nib – Gillot 303

The build-up to most of my sketches is basically the same. Having decided on my subject – I then work out the perspective.

VANISHING POINT

The main features are simply outlined to get the composition established.

Detail, texturing and shadowing are added in that order — until the 'feeling' of completion is reached.

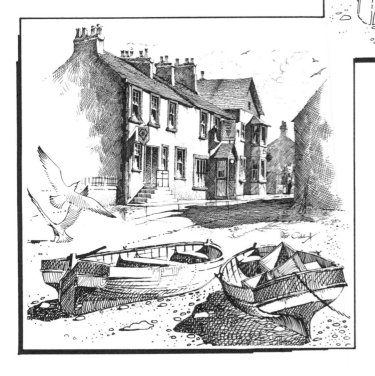

There is no 'golden rule' which says <u>finish</u>, except the sooner the better!

I like to use a theatrical analogy in this 3 phase process:- ① build the set. ② put the props in — ③ — then light it!

Getting life and character into a drawing

Tone and textures

Try for a pleasant balance between dark and light areas (tone), grouping the more interesting features of your drawing, rather than picking them out at random. A group of pictures on a bedroom wall is more attractive than a line of them or haphazard arrangement.

You can show textures by matching and shading in various ways. Some examples are shown in the following pages. Practise just 'suggesting' a texture, ie, a few planks in the right places, a few slates on a roof area, a minimum of stones on the beach.

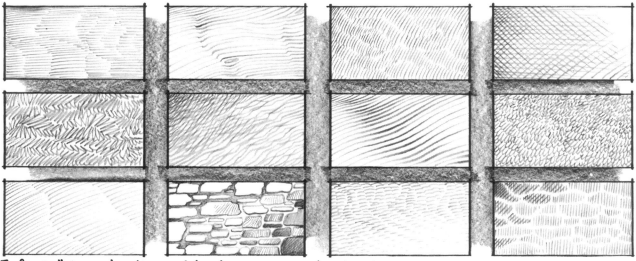

I find this selection of textures 'popping up' fairly regularly in all the sketches I do — irrespective of what medium I choose to draw with :- pencil, pen, pastels etc.

You can make interesting pictures of light and shadow alone, eliminating all other features. It is well worth trying to do one. You will learn a lot from the exercise and enjoy it. You will find it really surprising how much you can leave out and still achieve an excellent result—perhaps even a better one than a detailed drawing.

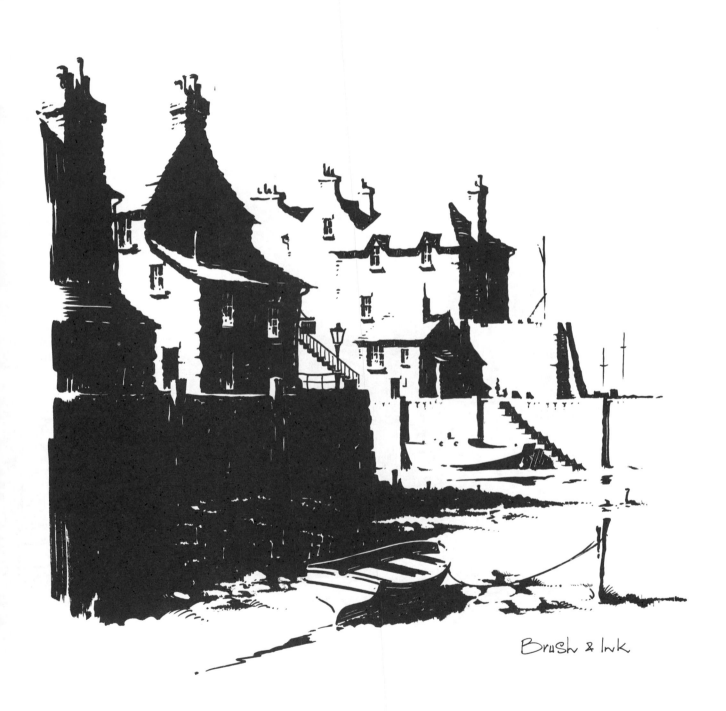

Brush & Ink

Light and shadow

Make good use of light and shadow; it can make an otherwise ordinary drawing into something special. And trying to capture the strange shapes cast by one object on another can be fascinating.

The following points are worth bearing in mind when drawing shadow.

a) Bright sunlight tends to glare on plain surfaces, like a wall or roof, thereby cutting down the amount of textured detail one would normally be able to see. So, in sunlight only suggest detail. On the other hand, a wall or roof in shadow encourages the eye to look closely, and more detailed texturing is therefore suitable.

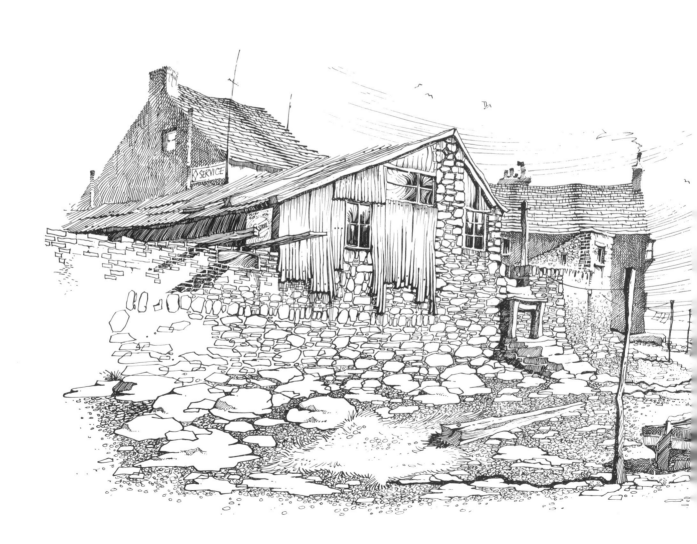

b) In bright sunlight, the shadow cast on the ground from the wall will be darker than the actual wall in shadow.

c) The edges of the cast shadow should be quite sharply defined. Because of reflected light, it ought to appear darker on the edges than on the inside.

d) The shadow cast by any object will follow the contours of the ground, or of the shape of any other object it falls across. This can provide some very dramatic patterns.

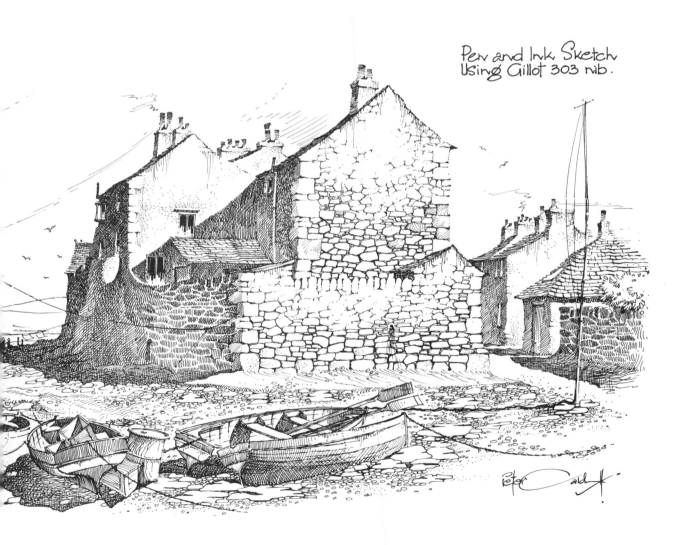

Pen and Ink Sketch Using Gillot 303 nib.

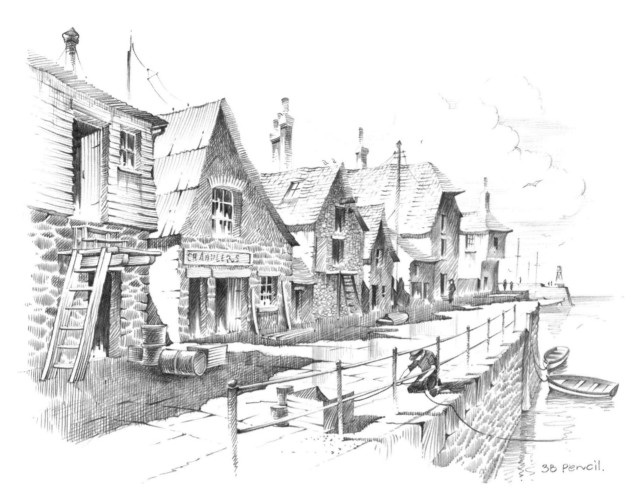

Weathering

This is something I particularly enjoy incorporating in a drawing. It is the general effect of ageing and rain marks which appear on all exterior walls and surfaces. All protrusions and fittings like sills, signs, carvings and overhanging eaves show the weathering drip-stains, where wind and rain beating against the building have caused an accumulation of water and dirt or rust to drip down the walls. Over a long period of time, discoloration occurs on the wall underneath these protrusions.

Weathering takes its toll on all things exposed to the elements. Next time you see a fishing trawler, notice the rust marks dripping down the hull from the anchor chains and scuppers and cleats.

Careful observation of where these marks occur will add great character to everything you draw. Windows, which reflect objects opposite them, offer further scope for giving life to a drawing. There is no need to go to great lengths to reproduce the exact shape of the reflection; you will enliven the window if you draw black, odd, unfinished 'splodges' on the area of glass.

Water and sky

Unlike buildings and other solid objects, which are more or less permanent and static, sky and water are always on the move. You can only hope to capture fleeting glimpses of their movement. It would be wrong to attempt to 'freeze' large detailed areas of sky and water. Far better to encourage the imagination with a few simple wispy lines.

Two very simple examples show how little is needed to make the imagination work:

The mere placing of a distant bird on an otherwise blank white space, immediately transforms that space into sky. A 'squiggle' to indicate reflection (in this case of a boat's mast), transforms the space below to water.

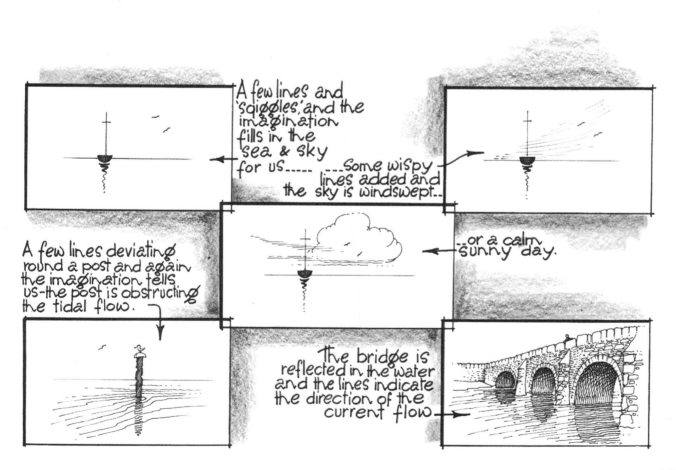

A few lines and 'squiggles', and the imagination fills in the sea & sky for us.....

....Some wispy lines added and the sky is windswept...

..or a calm sunny day.

A few lines deviating round a post and again the imagination tells us-the post is obstructing the tidal flow.

The bridge is reflected in the water and the lines indicate the direction of the current flow.

Water usually flows in one direction, unless obstructed by an object like a rock or post, in which case it will deviate, flow round, and join up again further down stream. This may seem obvious, but it is important that your linework showing the 'water flow' follows a similar course; even when reflections from a bridge or boat (p. 27) should stick to lines and strokes that go with the direction of water. When water is perfectly still, your strokes should be mainly vertical, perhaps with a 'squiggle' now and again, for variation.

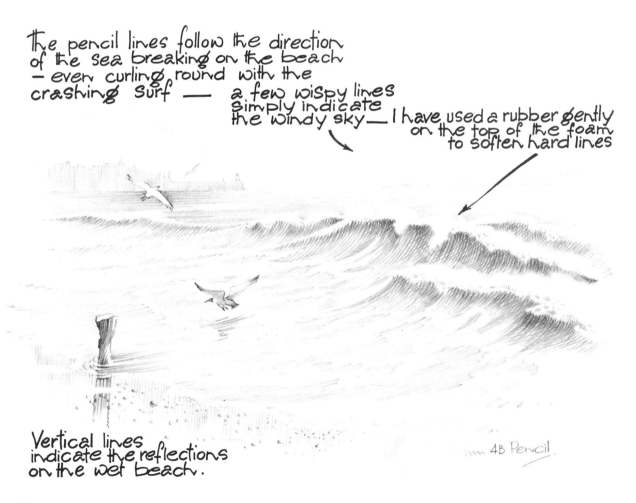

The pencil lines follow the direction of the sea breaking on the beach — even curling round with the crashing surf — a few wispy lines simply indicate the windy sky — I have used a rubber gently on the top of the foam to soften hard lines

4B Pencil.

Vertical lines indicate the reflections on the wet beach.

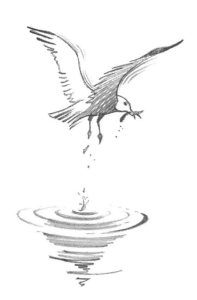

Notice what happens when a seagull first touches the water surface. Small circular waves are created, and the seagull's distorted reflection, which is just discernible, follows the same circular pattern as the waves.

As with everything in drawing, when dealing with sky and water, try to do what you have to do in the simplest, clearest way— 'suggesting', rather than filling in a lot of detail, wherever possible.

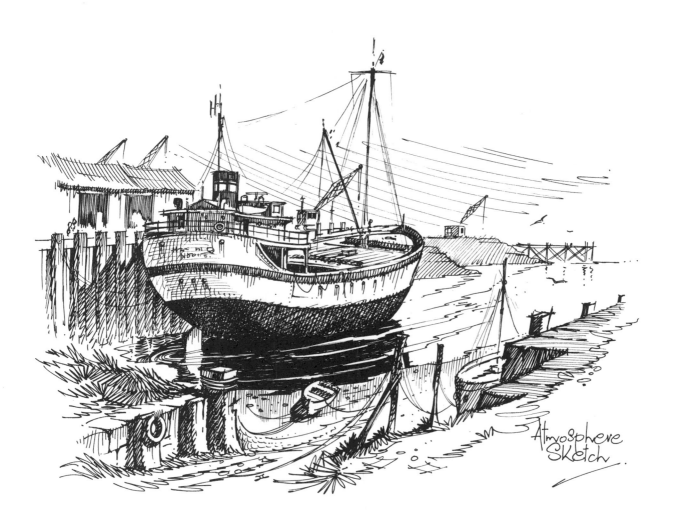

Atmosphere Sketch.

Mixing media

As your drawing improves, try mixing the different media available to you. The results can be very satisfying. An otherwise ordinary line drawing in pencil or ink will achieve extra dimensions if you add a grey or slightly tinted wash with a sable brush. Most media go well together, but I don't advise mixing pencil with Conté, wax crayons or oil pastels. Conté will not draw over pencil lines or any greasy surface.

Notice that most of the drawings in this book have been drifted off into the blank paper all round. The technical term for this is 'bleeding-off' or 'vignetting', and I have done it on purpose. The effect of this is to lead the eye into the picture, and also to give the drawing a more pleasing finish than it would have if it were taken right up to the edges of the paper. Moreover it makes framing easier. Drawing and sketching lend themselves particularly to vignetting.

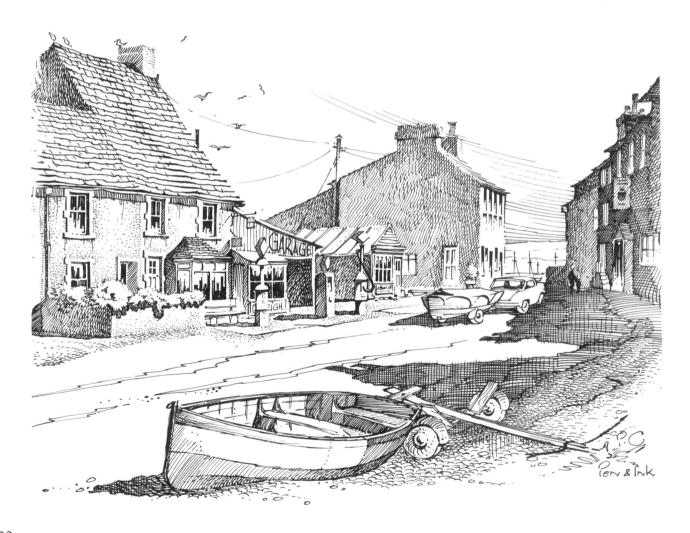

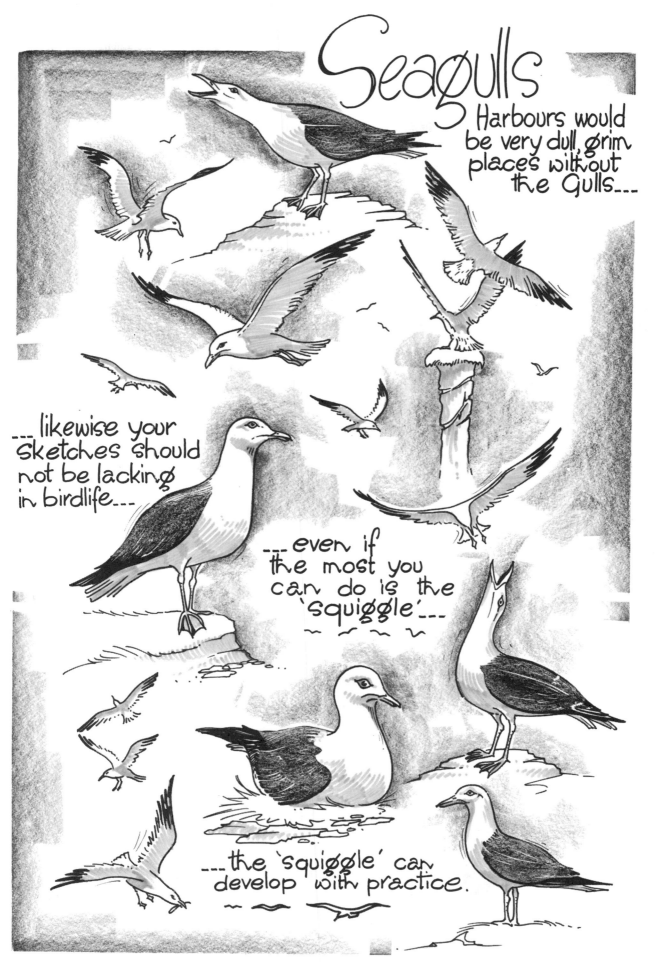

Seagulls

Harbours would be very dull, grim places without the Gulls...

... likewise your sketches should not be lacking in birdlife...

... even if the most you can do is the 'squiggle'...

.... the 'squiggle' can develop with practice.

Common problems

The temptation to include too much is a strong one, and it is worth stressing the message again here. Where there is an abundance of detail—in foliage, sky, slates, wood grain and pebbles—merely suggest. Suggested detail provokes the imagination, and more of a picture's appeal than one might think is provided by a subtly provoked imagination.

Avoid dirty pencil and pen work—keep lines clean, and keep your hands off the drawing surface. Grease and dirt will seriously hamper your efforts.

Don't scratch away at something you're not sure about. Draw when you are ready to draw, and then be positive about it, even if you know your technique could be better. Uncertainty in a drawing shows, no matter how you try to disguise it.

Beware of a lack of main interest in a drawing. There must have been something that principally caught your attention in the first place and this should be your focal point. Once having decided on it, avoid including anything that leads the eye away from it. Other points of the drawing should lead towards it. In the same way, beware of two special features competing for attention.

Avoid too centralised a picture, or one that is too precisely balanced on either side; anything that is too orderly and regular lacks character.

Don't be too ambitious to start with. Trying for a 'technicolor vistavision' spectacular is asking for trouble. Better to draw a rock or a boat really well than an insipid impression of San Francisco. When you can confidently draw small details, then you can raise your sights to more distant horizons. But do draw as large as your paper allows—don't cramp your style.

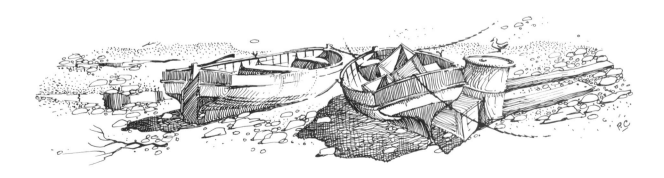

Different BOAT Positions

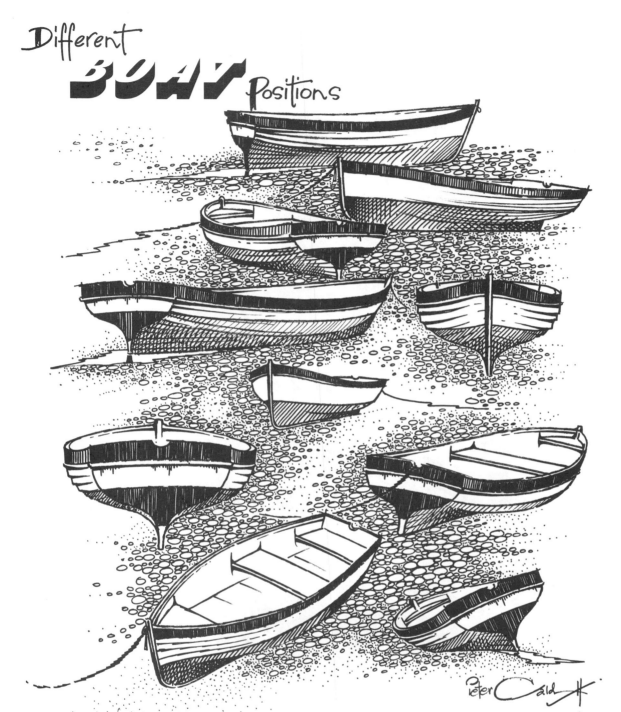

Pieter Cald...

Many people find drawing boats a difficult exercise — a useful tip to get started is to use the figure '8' as a guide line.

Elongated figure '8'

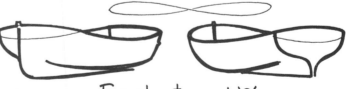

Foreshortened '8'

Try to draw with lines and textures which are sympathetic to the material the object is made of. For example, use hard jagged lines for hard jagged rocks; smooth, gentle, broad strokes for smooth gentle water ripples and reflections; broken, stipple lines for sandy, pebbly beach; graceful sweeping lines for seagulls in flight. In fact, always draw with feeling.

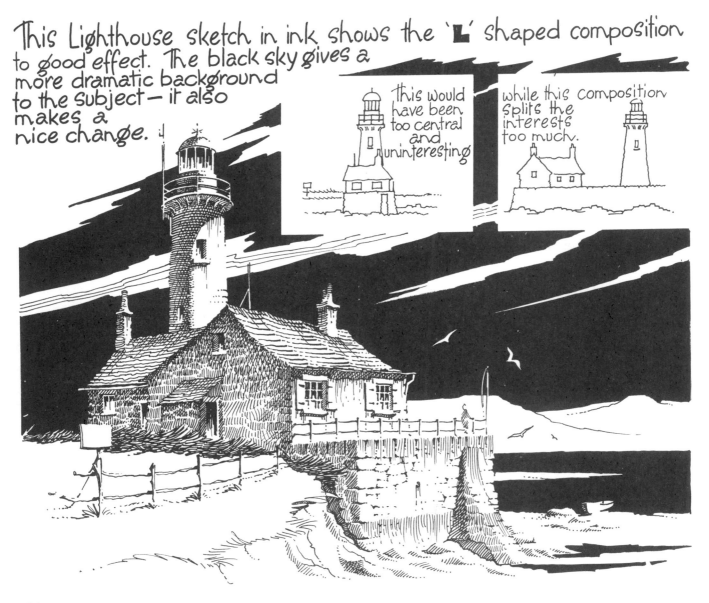

This Lighthouse sketch in ink shows the 'L' shaped composition to good effect. The black sky gives a more dramatic background to the subject – it also makes a nice change.

this would have been too central and uninteresting

while this composition splits the interests too much.

Examples of completed drawings

The following pages show a number of drawings of various kinds, which I have made over the years, with comments on what I was trying to do and how I set about it.

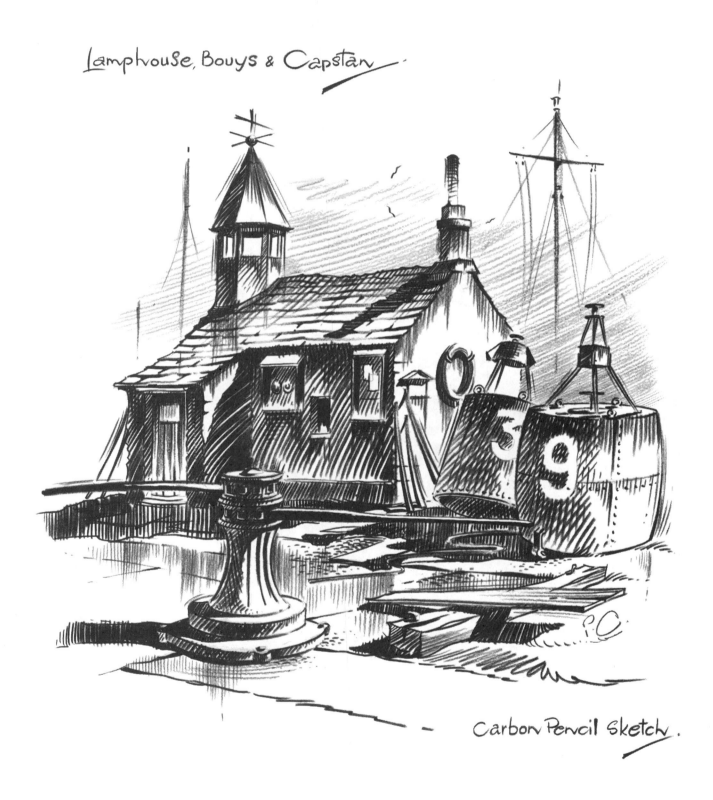

Lamphouse, Bouys & Capstan.

Carbon Pencil Sketch.

This overhead sketch of Fishing Trawlers gives a nice angle on these interesting boats — without the need for any fussy, unnecessary background.

I drew the big boat first, then extended some faint lines to give me vanishing points to help me with the second boat & quay

The composition uses the 'inverted' triangle as a balance ▼

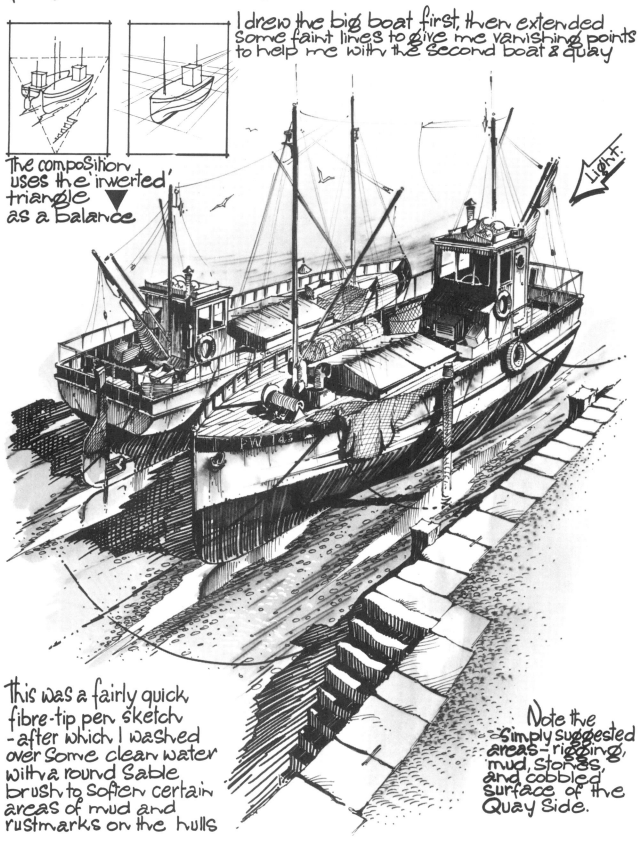

Light.

This was a fairly quick fibre-tip pen sketch - after which I washed over some clean water with a round sable brush to soften certain areas of mud and rustmarks on the hulls

Note the simply suggested areas - rigging, mud, stones, and cobbled surface of the Quay Side.

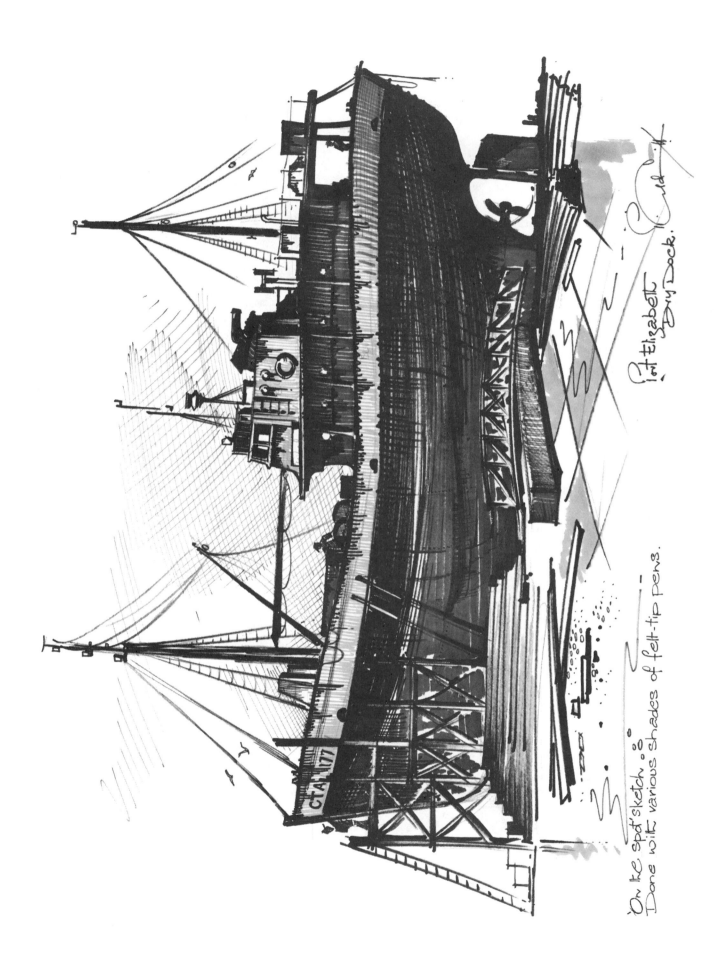

'On the spot' sketch.
Done with various shades of felt-tip pens.

Pt Elizabeth
Dry Dock.

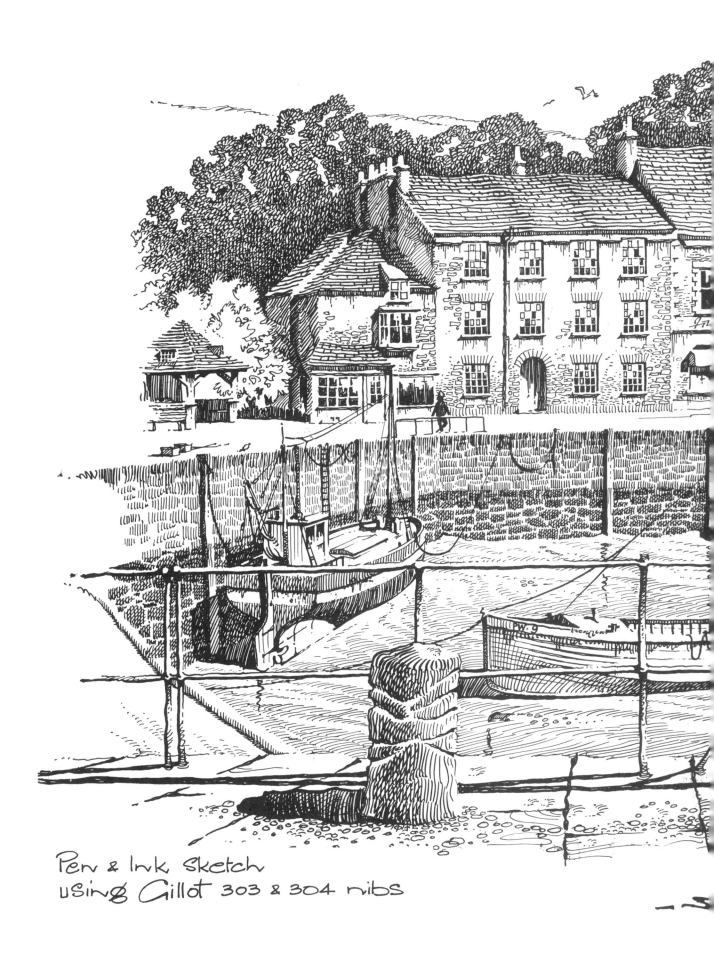

Pen & Ink Sketch
using Gillot 303 & 304 nibs

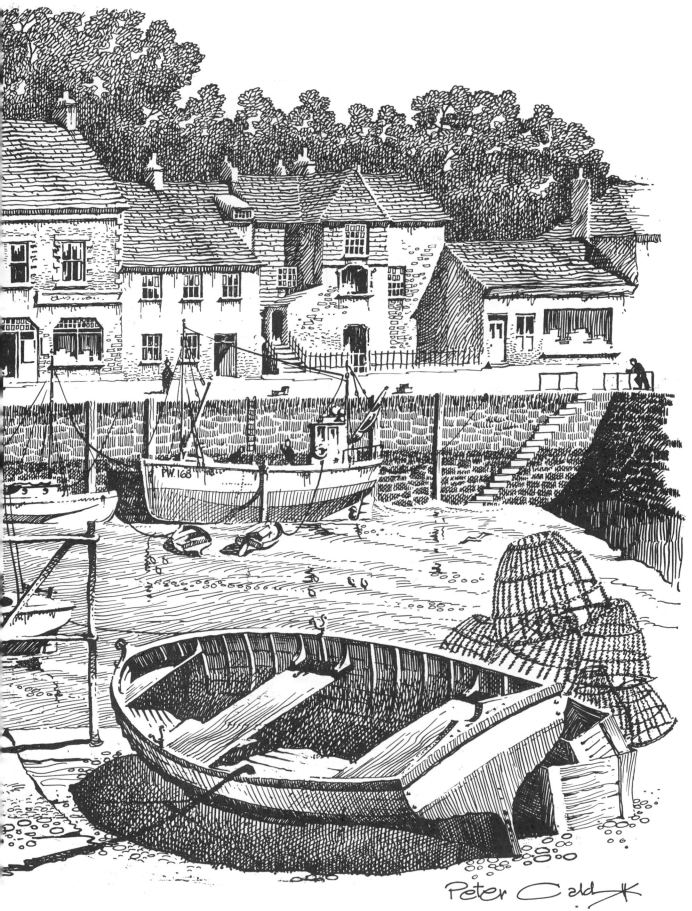

Peter Caldy

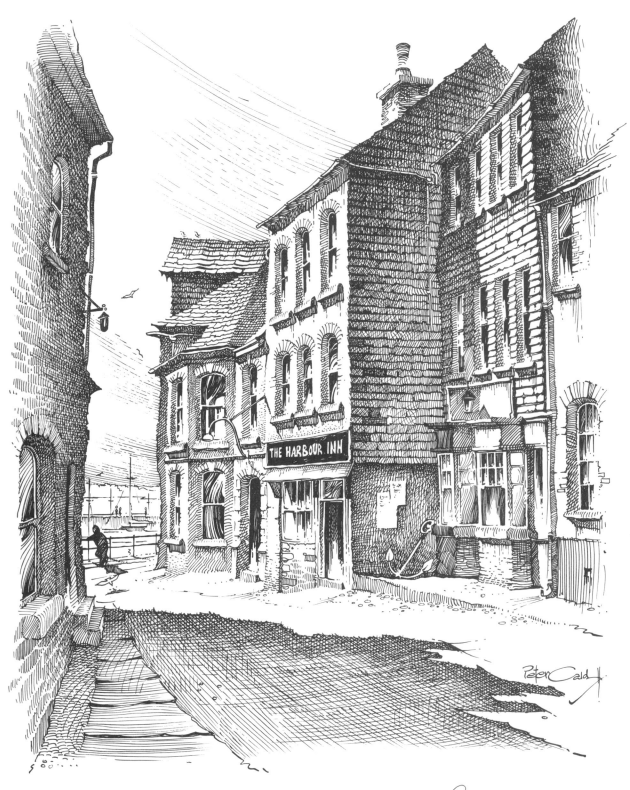

THE HARBOUR INN

Peter Cald...

Pen & Ink sketch
using Gillot 303 nib.

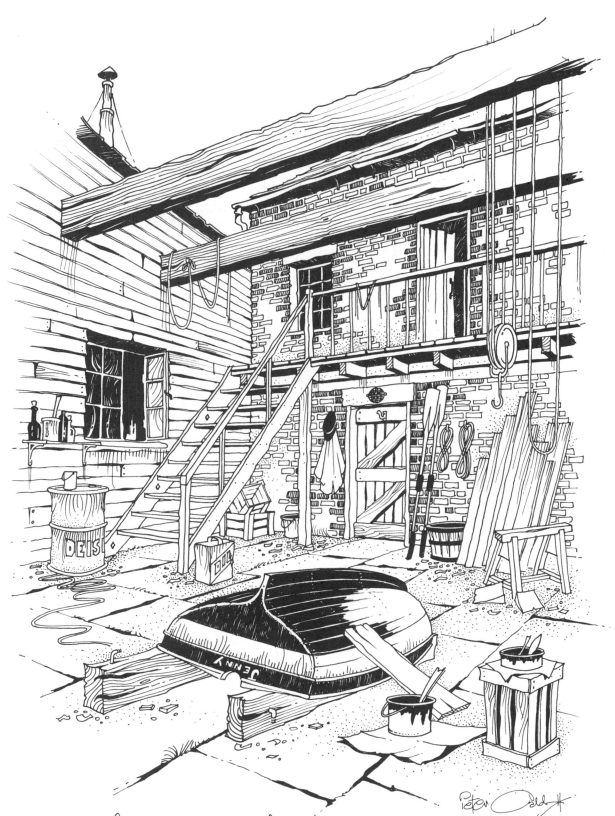

Corner of a boatyard — I find this kind of subject completely fascinating, with the wealth of 'bits & pieces' lying around. I could happily have done it in any medium—but chose a RAPIDOGRAPH pen as an exercise in its use.

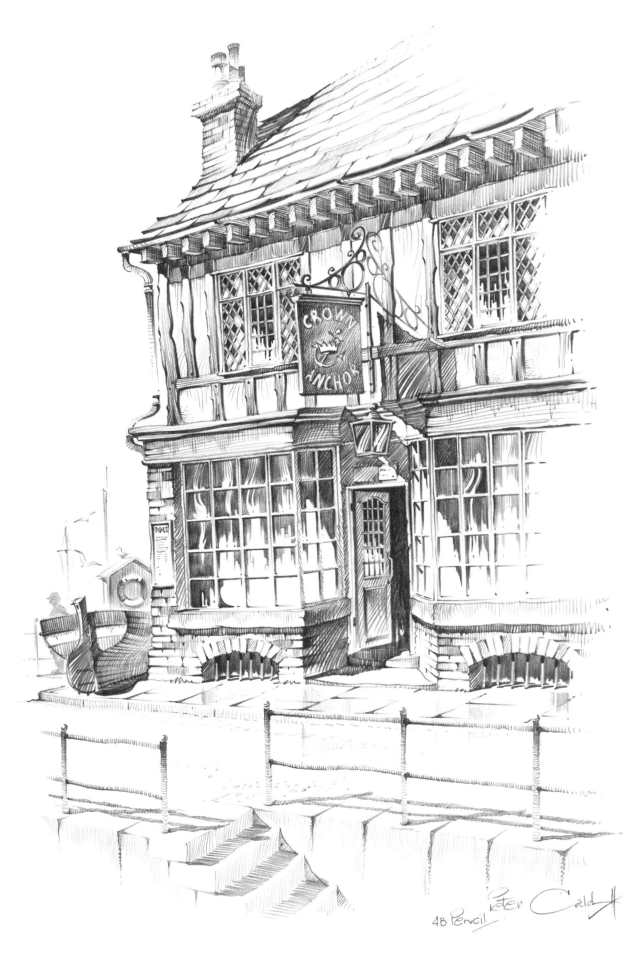

4B Pencil Peter Caldwell

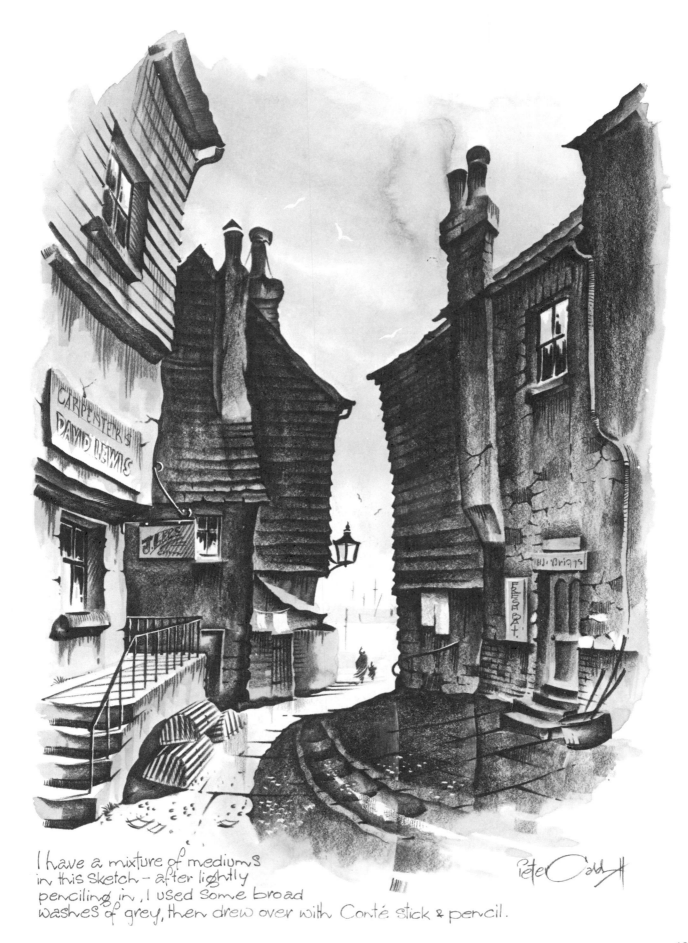

I have a mixture of mediums
in this sketch – after lightly
penciling in , I used some broad
washes of grey, then drew over with Conté stick & pencil.

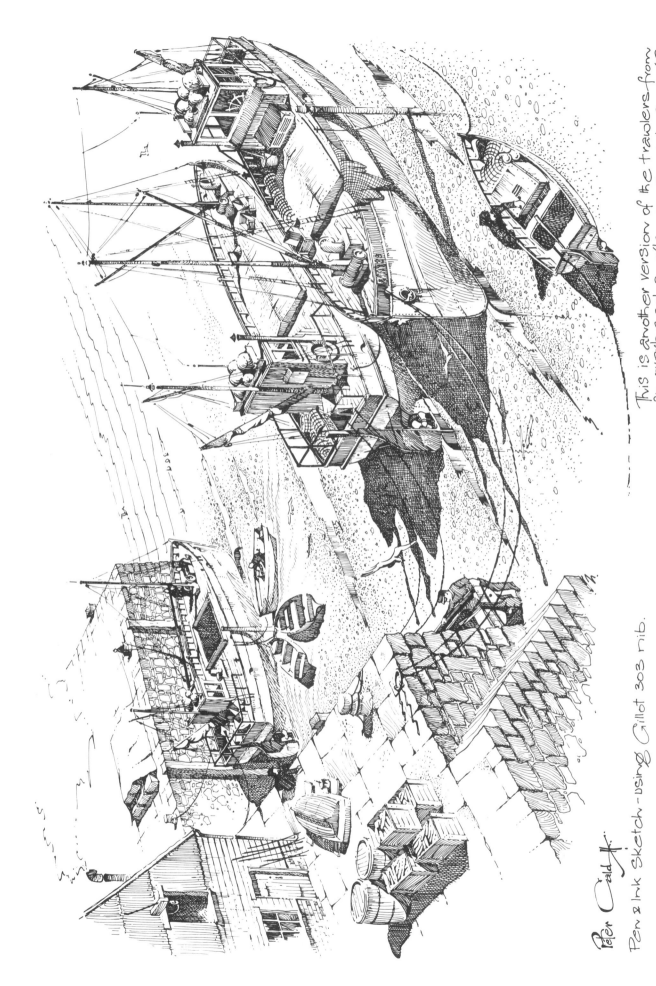

Peter Caldwell

Pen & Ink Sketch – using Gillot 303 nib.

This is another version of the trawlers from an overhead angle – on a previous page.

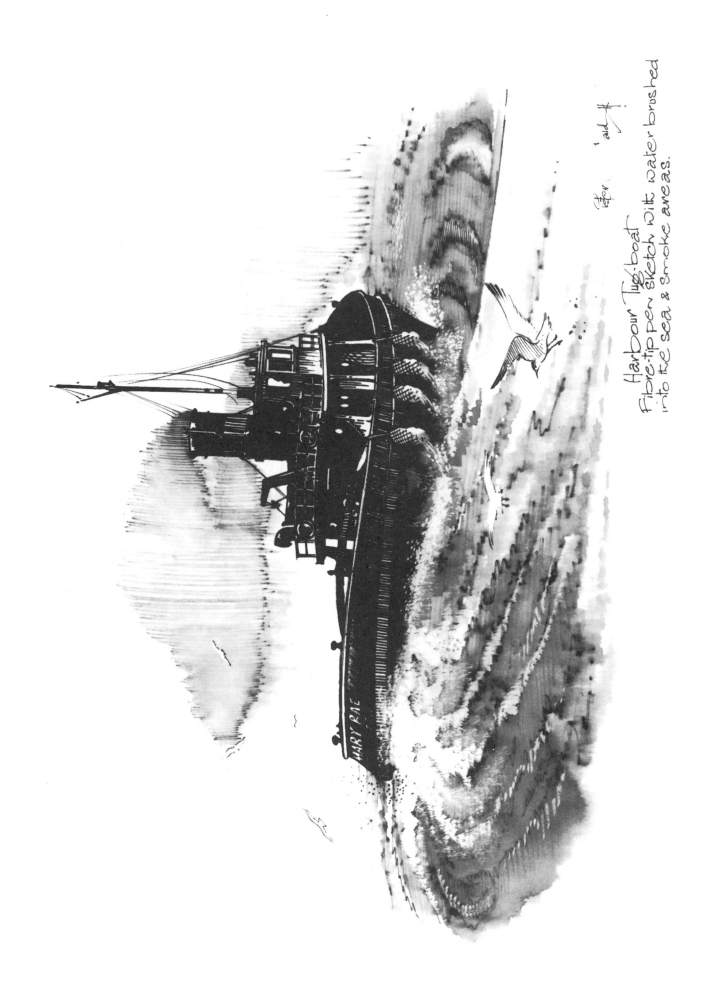

Harbour Tug-boat

Fibre-tip pen sketch with water brushed into the sea & smoke areas.

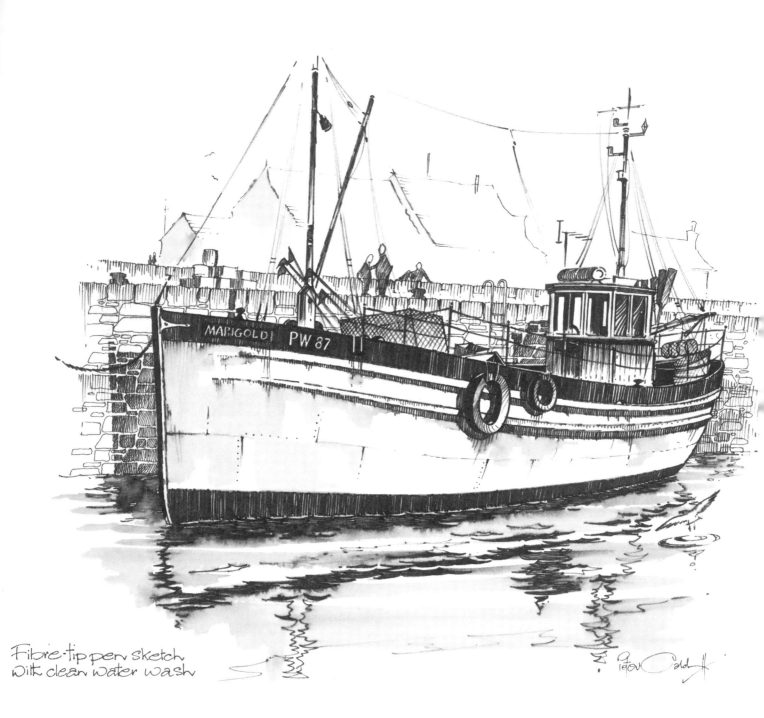

Fibre-tip pen sketch
with clean water wash

MARIGOLD PW 87

Peter Caldwell

'Work' & 'Play'
Conté stick sketch

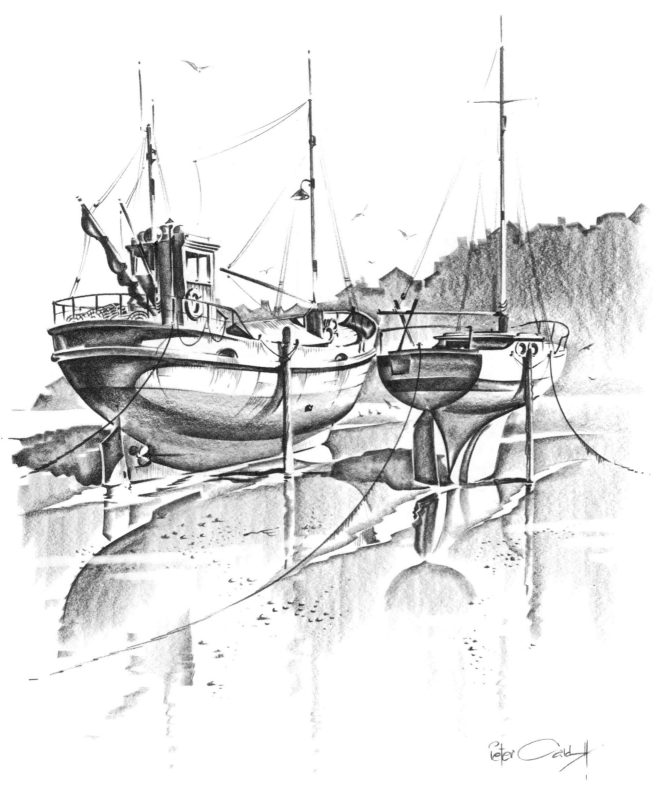

Peter Caldwell

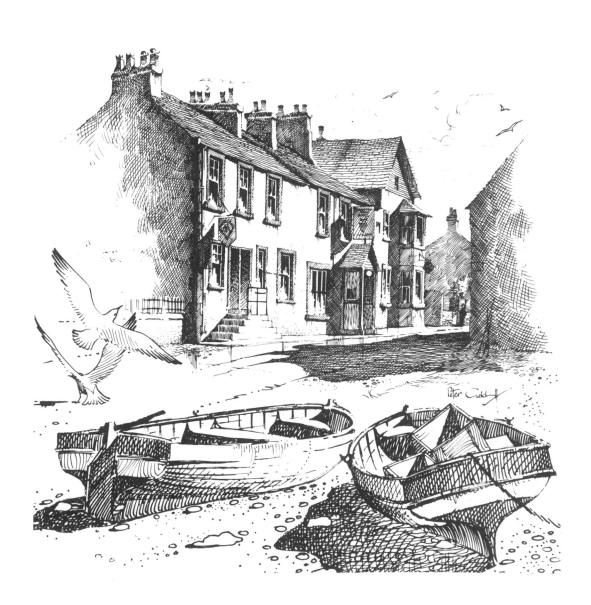